Y0-CAT-069

ANISH KAPOOR
DRAWINGS

DATE			
	APR 1 2 2002		

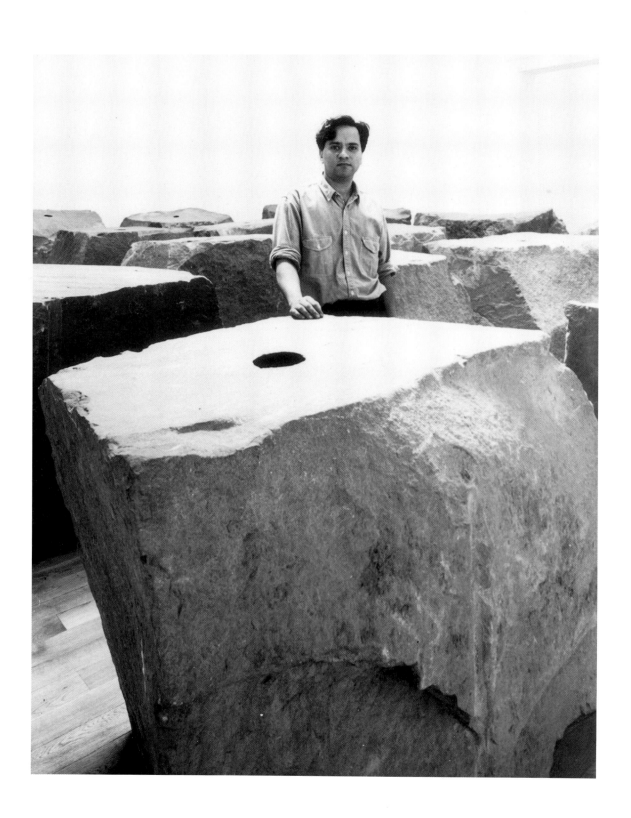

ANISH KAPOOR
DRAWINGS

Jeremy Lewison

TATE GALLERY

Exhibition Sponsored by

front cover
Untitled, 1989 cat.68

frontispiece
Anish Kapoor 1990 (photo: S. Anzai)

ISBN 1 85437 047 2
Published by order of the Trustees 1990
on the occasion of the exhibition at the Tate Gallery:
3 October–10 February 1991
Designer Kate Stephens
Photo credits: Tate Gallery Photographic Dept,
John Webb FRPS, Gareth Winters
The quotations from *Four Quartets* by T.S. Eliot
are reproduced by courtesy of Mrs Valerie Eliot and
Faber and Faber Ltd
Published by Tate Gallery Publications,
Millbank, London SW1P 4RG
Copyright © 1990 The Tate Gallery
All rights reserved

Phototypeset by
Southern Positives and Negatives
(SPAN), Lingfield, Surrey
in 'Monotype' Goudy

Printed on Consort Royal Silk 150gsm

Printed by Westerham Press Ltd,
Westerham, Kent

Contents

The Sponsors

Carroll, Dempsey & Thirkell is one of Britain's leading firms of graphic designers; their work includes creating the visual style for the Independent newspaper.

This year Carroll, Dempsey & Thirkell inaugurate a programme of sponsorship to encourage awareness of new art and to foster debate on design. Their sponsorship of the Annual Design Lecture at London's Design Museum begins later this autumn. The Anish Kapoor exhibition is Carroll, Dempsey & Thirkell's first sponsorship project and opens the new programme.

Carroll, Dempsey & Thirkell admire the forceful expression of spiritual values in Anish Kapoor's graphic work and are proud to begin their programme with this exceptional exhibition.

Foreword

Aɴɪsʜ ᴋᴀᴘᴏᴏʀ is one of a generation of British sculptors who came to prominence at the beginning of the eighties and who have subsequently acquired substantial reputations internationally. Kapoor was recently the British representative at the Venice Biennale where he was awarded the 'Premio Duemila'. Although his principal activity is making sculpture he is also a prodigious draughtsman. His drawings, however, have rarely been exhibited. Kapoor considers his works on paper as independent works of art rather than studies for sculpture and, although they have themes in common with his three dimensional work, his approach to making them is entirely different. Nevertheless they are imbued with the richness of colour and spirituality associated with his sculpture.

This is the first exhibition of his drawings to take place in this country and provides an opportunity to see his graphic work in depth. It is also the first in a series of exhibitions of works on paper to take place in the newly renovated lower galleries at the Tate Gallery. A tour to three further museums in the USA is currently in preparation.

The exhibition has been selected by Jeremy Lewison, Deputy Keeper of the Modern Collection, working in close collaboration with the artist to whom we extend our thanks for the time and effort he has devoted to the project. We should also like to thank Nicholas Logsdail and his staff at the Lisson Gallery for their co-operation in the organisation of the exhibition. Finally we are grateful to the sponsors, Caroll, Dempsey & Thirkell, for selecting this exhibition as their first venture in arts sponsorship. This initiative has been recognised by an award under the Government's Business Sponsorship Incentive Scheme.

ɴɪᴄʜᴏʟᴀs sᴇʀᴏᴛᴀ
Director

7

A Place out of Time

JEREMY LEWISON

We shall not cease from exploration
And the end of all our exploring
Will be to arrive where we started
And know the place for the first time

T S ELIOT[1]

THE ART OF ANISH KAPOOR represents a quest for self-discovery. His rich cultural background[2] combined with an interest in psychoanalysis are crucial to any discussion of both his sculptures and drawings. Kapoor's art manifests a desire to look inward in an attempt to know himself and, by implication, man in general. In a relatively materialistic age, when religion has been marginalised and even devalued, Kapoor achieves an art which is both human and spiritual employing a vocabulary of archetypal images. These include void, mountain, vessel, tree, fire and water. A discussion of these themes will be the principal concern of this essay.

On a number of occasions Kapoor has suggested that the creative part of his being is feminine[3] but this statement has never been explored in any depth. While it is regularly acknowledged that much of his imagery is concerned with the female body, this in itself is insufficient explanation of what might, at first, seem to be a rather extraordinary statement. Yet it actually probes deep into the ethos of his work. There can be no doubt but that his assertion must be interpreted in the light of the Jungian *anima*, the unconscious female characteristics within man. In *The Great Mother*[4] Eric Neumann, one of Jung's most faithful disciples, examines female archetypes as represented in art, particularly primitive art, and equates *anima*, or the 'transformative character', with creativity. The Great Mother, frequently symbolised by the vessel, 'is parthenogenetic and requires the man only as opener, plower, and spreader of the seed that originates in the female earth.'[5] The female is the source of all creation in her various guises as vessel, mountain, mother and ultimately world.[6] Kapoor's belief in the feminine nature of his creativity, therefore, is informed by the psychoanalytic notion of woman as Creator and this finds visual expression in the drawings themselves.

One of the subjects of Kapoor's drawings is the unconscious. He has stated that 'what I am trying to do is to make a picture of the interior, the interior of me', which suggests that the drawings are concerned with the interior of the body as a place, a container and a soul. For Kapoor the interior of the body is an unknown area, a chasm or a void which is both comforting and fearful, protective and restrictive, creative and destructive; indeed all the characteristics of the Great Mother who consists of the Good Mother and the Terrible Mother combined. These binary oppositions, central to the make-up of the Great Mother, are also key elements of Kapoor's images and, furthermore, of Indian, specifically Hindu, culture where the feminine deity (shakti) is perceived as the energising female counterpart or consort of the male god. In cults which elevate the female principle above the male, the female is seen as the energising force which stimulates the masculine potential which is seen as dormant – even dead – without her.[7] Kapoor's emphasis on the femininity of his creativity, therefore, also falls centrally within the culture of his country of origin.[8]

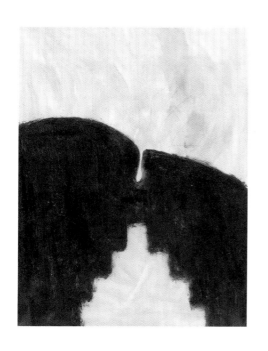

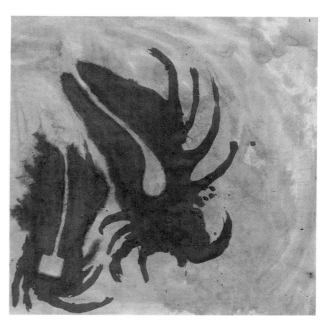

25 *Untitled* 1987 30 *Untitled* 1988

The emphasis on binary oppositions which are fundamental to Indian art and culture, as indeed is the relationship of complementaries, is also the basis of alchemy, a subject in which Kapoor also takes an interest.[9] According to Jung, writing in *Phychology and Alchemy*, 'Without the experience of the opposites there is no experience of wholeness and hence no inner approach to the sacred figures.'[10] It is for wholeness that Kapoor is searching in his work. Wholeness is the bringing together of polarities, the fusing of opposites as in alchemy and ultimately the oneness represented by the mandala.

Although such apparently simple images may be appreciated for their incredible beauty alone, they suggest themes based on multi-racial and timeless beliefs, archetypes which cross barriers and remain relevant throughout the history of mankind. Indeed, if Jung is to be believed, 'archetypes are not disseminated only by tradition, language and migration, but . . . they can arise spontaneously, at any time, at any place, and without any outside influence . . . It means that there are present in every psyche forms which are unconscious but nonetheless active.'[11] This is the essence of the theory of the collective unconscious.

Kapoor's drawings relate to primitive culture not only through archetypal forms but by the expression of primal urges and fears. It should not be forgotten, however, that he was trained in London within a Modernist tradition of art, although it is becoming clearer, as the examination of Modernism proceeds, that much of it is concerned with similar primeval ideas. It would be simple to relate Kapoor's work to that of Barnett Newman, Jackson Pollock and Mark Rothko and even of Ad Reinhardt, all of whom he admires. Similarly much has often been made of Kapoor's connections with Minimalism and clearly his pursuit of an image of wholeness relates closely, in some respects, to the unitary nature of Minimal Art.[12] But just as we should not insist too much on the importance of his Indian heritage, we should similarly not seek to imply that his art is simply a continuation of the traditions of Modernism, as represented in the work not only of the Abstract Expressionists or the Minimalists, but even in the art of Yves Klein or Lucio Fontana. Kapoor draws upon a blend of a number of different cultural traditions and his art cannot easily be categorised.

It is abundantly evident, from looking at the drawings and from discussions with Kapoor, that he is obsessed by a number of images or themes as gateways to the mystery of life. The one which recurs with the greatest regularity is the mountain which, it has already been noted, is a female archetype.[13] The mountain has a variety of connotations all of which are relevant to an understanding of Kapoor's imagery. It is a sacred place of communication with God in Islamic, Hindu, Christian and Jewish religions. Mohammed, Moses and Christ (on the Mount of Olives) all communed on mountains while Hindu temple architecture refers to caves and mountains. In an alchemical context the mountain was considered to be a source of *prima materia*, the essence of life, the equivalent to the unconscious. Within Christian

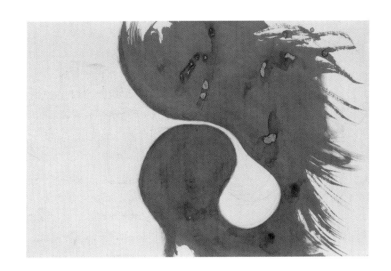

26 *Untitled* 1987 46 *Untitled* 1989

iconography it has been associated with the Madonna – for example Leonardo's 'Virgin of the Rocks' – a connotation also found in Kapoor's drawings, as in number 29 [repr. in col. p.38], which on one level he considers equivalent to the depiction of the Virgin. Here the 'figure' appears steadfast, her head surrounded by a halo of energy. The inner garment of the Virgin is traditionally red, her outer garment blue, red suggesting life forces while blue symbolises cosmic powers. Kapoor omits the blue thereby evoking the Madonna's essential worldliness and fleshness. However, the image defies a singular interpretation and works on a number of different levels to suggest, among other things, fire, passion, fertility, strength and blood. While it is possible to be specific about some aspects of Kapoor's motifs, his images act as triggers and transmitters of energy in a wide-ranging way.

The mountain is traditionally protective and in German a number of words with such connotations are derived from *Berg* (mountain) – *sich bergen* (to take refuge), *Geborgenheit* (safety) etc.[14] On the other hand it is also associated with confinement. The cave is a part of the mountain and by the law of *parts pro toto*, where an identity established between persons and objects applies to their parts also, the mountain becomes a refuge and a tomb (see for example no.25, repr. p.12). When related to the female body it becomes a vagina or a womb, a source of excitement and creativity, but also a dark void of mystery and fear and a place of restriction. The male enters the female erect and exits withered, a parallel to the cycle of life and death and testimony to the power of both the Good and Terrible Mother, the latter personified in Hindu mythology in the form of Kali. In many of Kapoor's drawings we find a mountain with an opening leading to a cavernous interior. It is difficult not to associate this with the female body although some images suggest the ambiguity of an androgynous form. For example, in number 12 [repr. in col. p.32], a shaft of red penetrates upwards through the mountain suggesting both vagina and penis. As vagina its redness implies the notion of wound, a puncturing of the skin, a theme which recurs in Kapoor's work in the form of slits. It also suggests fire, traditionally both a creative and destructive force neither definitely male nor female.[15] The representation simultaneously of two polarised states of existence in this and other images (for example nos.30 [repr. p.12] and 55 [repr. in col. p.48]) suggests, through the ambiguity of positive and negative space, that organs and orifices are interchangeable.

If some images represent metaphorically the vaginal canal (nos.14 [repr. in col. p.33], 26 [repr. p.14] and 49 [repr. in col. p.46]) others denote ovaries suggesting fertility (nos.8 [repr. in col. p.31], 46 [repr. p.14] and 47) or connote the vulva (nos.3, 65 and 71 [repr. p.16]). While Kapoor's work is never literally descriptive in the manner of Leonardo's anatomical drawings, he acknowledges Leonardo as an artist of personal importance. Kapoor appreciates not only Leonardo's descriptive powers but his ability to suggest the universality of forms, even when examining them in their minutest detail. For Kapoor, Leonardo's

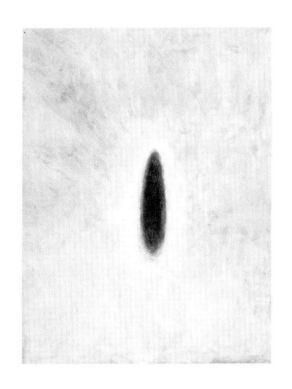

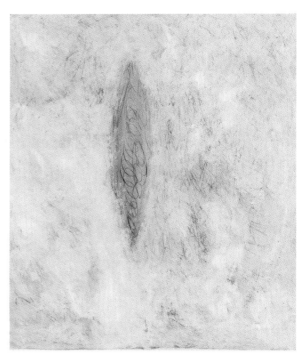

65 *Untitled* 1989 71 *Untitled* 1989

concentration on the microcosmic does not prevent him from extending the meaning of his work to the macrocosm. He finds Leonardo's Leda remarkable for the way in which her touseled hair echoes the forms of the plants around her and suggests her connectedness with the universe.[16]

Vegetation is another motif in Kapoor's work, particularly the tree which appears as an image of dual character. In the history of art and literature its upward thrust has often been associated with the male phallus but it is also a symbol of femininity. A tree is a protector. It houses nests. As a fruit-bearer 'it bears, transforms and nourishes; its leaves, branches, twigs are "contained" in it and dependent on it . . . In addition the trunk is a container, "in" which dwells its spirit, as the soul dwells in the body.'[17] In its male and female 'double symbolism', the tree is a fine example of what Neumann terms the uroboros and this duality is found in a number of Kapoor's images, for example number 67 [repr. in col. p.56], where an upside down tree suggests vagina and phallus. The liquidity of the surface is a metaphor for sexual fluids. Both this work and number 68 provide clear evidence of the unity of human and natural forms, for where in the former the tree is suggestive of sexual cavities and members, in the latter its roots evoke veins and capillaries.

All body openings are considered both sacred and taboo and have always played a special role in man's artistic representation. Openings feature particularly prominently in Kapoor's art as the point of access to the interior and therefore to the unconscious, with which the interior of the body is archetypally identified.[18] An orifice is an entry to the creative areas of the body, those which nurture and nourish the foetus and those which process and transform. One opening is the channel through which woman gives birth to the child; through another she gives birth to faeces.

The heavily textured, viscid nature of many of these drawings has scatological overtones. Among those where this is particularly evident are numbers 55 and 42 [repr. in col. pp.48, 44] which in its simultaneously glutinous and dry surface, negative and positive space, lightness and darkness is suggestive of both the rectum and faeces. According to Kapoor, these drawings contain 'a lot of shit and a little bit of sky', a description which evokes the alchemical change of base metal to precious metal and the sense of spirituality which lies ultimately at the heart of darkness. Number 24 [repr. in col. p.35] alludes to these ideas in its excremental texture and shapes. At the centre lies a rectangle of clarity, a way through the morass to transendence.

Sometimes, however, the passage or cavern can be the *horror vacui*, the abyss or the chasm, a place of dread, 'the growing terror of nothing to think about'.[19] In Kapoor's drawings, more than in his sculpture, there is a sense of fear of the void, represented as the darkness of the unknown (no.74 [repr. in col. p.60]), a passage leading to nowhere and

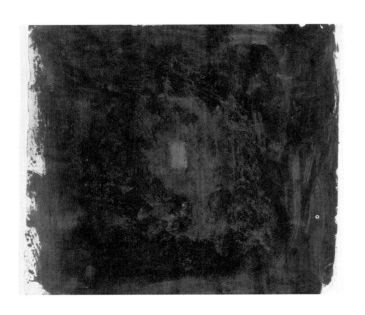

52 *Untitled* 1989 62 *Untitled* 1989

everywhere and therefore potentially either destructive or creative.[20] The thrill imparted by such works as numbers 17 and 74 may be related to the eighteenth century concept of the sublime. According to Hugh Blair the sublime

> *produces a sort of internal elevation and expansion; it*
> *raises the mind much above its ordinary state; and fills it*
> *with a degree of wonder and astonishment, which is*
> *certainly delightful; but it is altogether of a serious kind; a*
> *degree of awfulness and solemnity, even approaching to*
> *severity, commonly attends it when at its height; very*
> *distinguishable from the more gay and brisk emotions*
> *raised by beautiful objects.*[21]

Edmund Burke, one of the leading theorists of the sublime, described its sources in some detail:

> *Whatever is fitted in any sort to excite the ideas of pain,*
> *and danger, that is to say, whatever is in any sort terrible,*
> *or is conversant about terrible objects, or operates in a*
> *manner analagous to terror, is a source of the* sublime;
> *that is, it is productive of the strongest emotion which the*
> *mind is capable of feeling.*[22]

Pain is only sublime when its causes do not immediately affect us, Burke maintained, and when viewed at a distance is 'delightful' because it incites the 'passions belonging to self-preservation.'[23] Causes of such pain, according to Burke, are as varied as darkness, infinity, vastness, light and colour and lead to a sense of elevation and communion with God. Kapoor's drawings embrace all these characteristics but, in place of communion with God, he seeks its equivalent, wholeness.

Traditionally, in every religion, communion with God is effected in a place of special significance – temple, church, synagogue or mountain. In pagan times it might have been within a stone circle, a magic circle or around a totem pole. Whatever its exact nature, for Kapoor it is not so much a place of transition between the terrestrial and the spiritual, which implies that one can move from one to the other, as an area which divides the two but in which both may be present. Thomas McEvilley equates this with *makom* (Hebrew for place)[24] but *makom* is the habitation of the invisible God and synonymous with his being. It is not the

place of communication for it is unreachable. McEvilley is correct, however, when he states that the primal sense of the sanctity of space and a preoccupation with 'the Origin, the Primal Moment and the First Light' are fundamental tenets of Modernism.

The synagogue, the mountain and the temple are *cordons sanitaires* or ante-chambers, just as the picture plane is the space between the viewer and the void beyond it. The void itself cannot be entered but like the Promised Land for Moses, the prospect of the wholeness it contains may be viewed from afar. The sense of distance and the sanctity of place are particularly strongly felt in number 52 [repr. p.18] where the blue rectangle, so deliberately located near the centre, suggests a gateway to eternity.

In the drawings this notion of wholeness is normally given visual form by the depiction of the sphere, for example numbers 57, 59 and 63 [repr. in col. pp.50, 52, 54] where roundness suggests completeness. In the latter the aureole surrounding the blue sphere endows the image with a sense of spirituality and presence, in a manner somewhat reminiscent of the mature works of Rothko which pulse quietly with energy. Indeed energy resides at the point of contact between two colours, the *coniunctio* of two separate elements. Another passage in *Burnt Norton* appears to describe Kapoor's achievements in such works:

> *At the still point of the turning world. Neither flesh nor fleshless;*
> *Neither from nor towards; at the still point, there the dance is,*
> *But neither arrest nor movement. And do not call it fixity,*
> *Where past and future are gathered. Neither movement from nor towards,*
> *Neither ascent nor decline. Except for the point, the still point,*
> *There would be no dance, and there is only the dance.*
> *I can only say, there we have been: but I cannot say where.*
> *And I cannot say, how long, for that is to place it in time.*
> *The inner freedom from the practical desire,*
> *The release from action and suffering, release from the inner*
> *And the outer compulsion, yet surrounded*
> *By a grace of sense, a white light still and moving,*
> Erhebung *without motion, concentration*
> *Without elimination, both a new world*
> *And the old made explicit, understood*
> *In the completion of its partial ecstasy,*
> *The resolution of its partial horror.*[25]

Kapoor's spheres suggest timelessness, completeness, resolution of fear, release from suffering and anxiety, the still point at the centre of the chaotic vortex. This is not dissimilar from the use Blake often made of the globe in the guise either of the sun or the moon, or indeed of a quasi mandala as in 'The Sun at his Eastern Gate'. Blake is an artist whom Kapoor particularly admires not only for his sense of spirituality but also for the way in which he evokes spiritual presence through light.

The location of the principal motifs in Kapoor's work is particularly significant and parallels metaphorically the importance he attaches to the notion of place. Position is determined by discipline, control and instinct. The images are poised within a field and even the smallest motifs have great presence. Some are slow to reveal themselves as though replicating the act of creation itself, while others have the immediacy of life.

Each drawing is usually begun near the centre of the sheet and while it develops relatively spontaneously Kapoor knows from the outset what kind of motif he is dealing with. The drawings are quickly achieved and are direct expressions when compared with the sculptures, which require greater planning and considerable time to create. Furthermore, while in his sculptures Kapoor generally eschews autographic marks and employs assistants to help him carve into stone, the drawings stress the primacy of the mark and the hand of the artist.[26] Many of these marks are made instinctively, the artist acting as transmitter of forces and thoughts beyond the conscious.[27]

Frequently the sheet of paper is covered in a dark wash of brown, an (unconscious?) equivalent to the initial alchemical state known as *nigredo* (blackness) which is either present as a quality of *prima materia* or else produced by the separation of the elements (earth, water, fire and air).[28] From this base Kapoor proceeds to extract the image using a relatively narrow range of rich colours. His principal colours are black, white, yellow, red and blue, of which the first four, fortuitously perhaps, correspond to the four stages of alchemy: *melanosis* (blackening), *leukosis* (whitening), *xanthosis* (yellowing) and *iosis* (reddening). He regards blue as a 'cosmic' colour. The four colours, in alchemical terms, correspond to the four elements and four qualities (hot, cold, dry and moist). Although Kapoor himself does not use them so precisely and does not regard his colours as being directly related to the tetrameria, there are interesting correspondences, not least in his assertion of the spiritual power of colour.[29] He believes that colour has the power not only to transform feelings and provoke emotions but to be a physical presence in itself. It has 'a tremendously real value. There are certain circumstances in which red can be fire, certain circumstances in which it can be heart, certain circumstances in which it can be vagina. White can be something physical or just white. Colour has an almost direct link with the symbol-forming part of ourselves. That is something we have without formal education. It is just there.' He states that he is interested in

very vivid colour because it 'has a bigger reality than weak colour'. His attitude to materials can be similarly physical when, for example, he incorporates actual earth for both its literal descriptiveness and as a metaphor for the Earth and, by extension, the female body or vessel. Earth itself is a skin which may be punctured or wounded like flesh. Number 40 [repr. in col. p.42] is a particularly fine illustration of this notion with its scaley, literally earthen surface.

Even when Kapoor uses white he does so with positive force. (see nos.64 [repr. in col. p.55] and 62 [repr. p.18]). In alchemy, the state of whiteness is the combination of all four colours and represents the main goal of the process, although not the ultimate aim. According to Jung 'It is the silver moon condition, which has still to be raised to the sun condition. The *albedo* is, so to speak, the daybreak, but not till the *rubedo* is it sunrise.'[30] Although we should beware of reading any of Kapoor's images as direct translations of Jung's exposition of the traditions of alchemy, he does occasionally use Jung's and Neumann's books as lexicons.

A number of his drawings consist either of pure whiteness or whiteness arising out of an earthy base. In addition to any alchemical interpretation it should not be forgotten that white has been an important colour within the history of Modernism. Kandinsky recognised it as having 'the appeal of nothingness that is before birth, of the world in the ice age.'[31] More recently white has been the principal theme of the work of Robert Ryman with which comparison of Kapoor's drawing number 63 may be made in terms of the emphasis on brush stroke and texture. That Kapoor can use paint as both substance and metaphor, however, shows the complexity which he achieves and the transcultural context in which he is working.

In only one of the drawings does he actually achieve the literal goal of the alchemist, to make gold. In number 2 gold leaf and varnish are combined to suggest that gold is created out of the conjunction of water and earth (brown pigment diluted in varnish), from which it emerges as a spiritual force, carefully placed within the rectangle of the sheet. Indeed water, as represented by dilute pigment or varnish, features prominently in Kapoor's work and is suggestive of creativity and the act of creation. Again this is consistent with the archetype. When a child is born the waters are broken; the new born child is nourished by his mother's milk; rain replenishes the earth. Finally, in the book of *Genesis* heaven and earth were formed by dividing the waters.

The birth of cosmic order is an underlying theme of a number of Kapoor's drawings and is nowhere more apparent than in numbers 56 and 60 [repr. in col. pp.49, 53]. In the former the spiral may be interpreted as the initial stages of the Great Round, spinning on its own axis, gathering together the elements (earth, water, fire and air) to make order out of chaos. The process of making this drawing parallels the alchemical process. Kapoor dissolves

pigment (earth) in varnish (water) and allows different solutions to puddle and bleed, one on top of another, and to transform themselves often with little intervention. The process is somewhat magical and beyond strict control and comprehension in the sense that, although he knows how it is achieved on paper, he has stated that he 'would love to get some of those effects into my sculpture but I just do not know how'. The principles of alchemy were as mysterious to the alchemists.

It is perhaps drawings such as numbers 56 and 60 that come closest, visually and thematically, to the early 'biomorphic' work of the Abstract Expressionists such as Newman and Rothko. Between 1946 and 1947 Rothko painted a number of paintings aquatic in character of which one was given the title 'Aquatic Dream.'[32] Rothko was extending and abstracting from his earlier 'primitive' imagery to make images which continued to have universal significance but which were less recognisably tied to known myths. He and Adolph Gottlieb, with whom he formed a close alliance in this period, believed in an art in which 'the subject is crucial and only that subject-matter is valid which is tragic and timeless.'[33] Gottlieb also wrote that 'All primitive expression reveals the constant awareness of powerful forces, the immediate presence of terror and fear, a recognition of the natural world as well as the eternal insecurity of life.'[34] Although the sources of Rothko's and Gottlieb's art at that time were principally Surrealist and primitive, the expression of their understanding of art seems to anticipate Kapoor's intentions and achievement. In the case of Barnett Newman there is an obvious overlap between his 'Genetic Moment' 1947[35] and Kapoor's interest in creation, birth, sexual passages and cosmos. Indeed this painting contains a brown sphere surrounded by a halo of light, not dissimilar from Kapoor's voids and globes, as well as forms suggesting vaginal canals. Although a case might be made to suggest that Kapoor has been influenced by Newman, such similarities show more importantly the universality of both the themes and the forms. Furthermore there are enormous differences between Kapoor's work and Newman's early paintings, not simply in texture and scale but in energy. Although 'Genetic Moment' deals with a cosmic subject it remains resolutely small scale. The forms are self-contained and clearly defined within limited spaces so that the work appears to be microcosmic. It was only later that Newman's work became infinitely expansive and evoked an untouchable vastness. In Kapoor's drawings space remains undefined as forms swirl about and pin pricks of light suggest infinity, rendering the scale macrocosmic. For him the cosmos is the infinite space of the interior projected outwards, defined neither by time nor distance, but by radiant light.

Radiance is of central importance to Kapoor's work. Streaks of coloured light radiate in an energetic vortex around a central point of stillness in many of the drawings, a metaphor for the still pivotal point of a pendulum or the fixed point in the universe (see for example

nos.1 [repr. in col. p.29], 18 and 40 [repr. in col. p.42]). One source of light is derived from friction: the friction of two sticks being rubbed together, a natural parallel to the sexual act. The former results in fire and light, the latter in orgasm and birth of humanity. Both ends are ultimately explosive, productive and transformative.[36] Energy is also derived from gesture and colour: the speed and violence of the mark and the abutment of colours. It can be the energy of aggression or the energy of deep, spiritual strength.

The struggle of the artist to make art is a parallel to and metaphor for the Creation myth. Each time he makes a work he begins from scratch, attempting to approach nearer to the truth, and yet each time he fails because the truth is unknowable. Anish Kapoor's work is an expression of that quest which Eliot found so frustrating:

And so each venture
Is a new beginning, a raid on the inarticulate
With shabby equipment always deteriorating
In the general mess of imprecision of feeling,
Undisciplined squads of emotion. And what there is to conquer
By strength and submission, has already been discovered
Once or twice, or several times, by men whom one cannot hope
To emulate – but there is no competition –
There is only the fight to recover what has been lost
And found and lost again and again: and now, under conditions
That seem unpropitious. But perhaps neither gain nor loss.
For us, there is only the trying. The rest is not our business.[37]

1 T.S. Eliot, 'Little Gidding', V, vv. 239–242, *Four Quartets*. I am grateful to Ivor Braka for drawing my attention to the possible relevance of *Four Quartets* to the work of Kapoor.

2 Kapoor was born in Bombay. His father is Indian and his mother is Iraqi Jewish. Since 1973 he has lived in England.

3 See for example 'Mostly Hidden. An Interview with Marjorie Allthorpe-Guyton' in *Anish Kapoor*, exh. cat., The British Council, 1990, p.49. This was an assertion he repeated during an interview with the present author on 19 July 1990. All statements made by the artist in this essay are taken from this interview unless otherwise stated.

4 Erich Neumann, *The Great Mother. An Analysis of the Archetype*, first published 1955. All quotations are taken from the second edition published by Routledge and Kegan Paul, 1963.

5 Neumann, p.63.

6 Neumann forms the equation that Woman = Body = Vessel = = World.

7 See *In the Image of Man*, exh. cat., Arts Council of Great Britain, 1982, p.219.

8 Interestingly, Judaism, to which Kapoor feels a strong attachment, is androcentric. God is personified as a male; Eve is born of Adam's rib.

9 C.G. Jung's *Psychology and Alchemy* is another important source of reference for Kapoor. It was first published in England in 1953. All quotations are taken from the reprinted paperback edition 1989 of the second edition 1968, published by Routledge.

10 Jung, p.20.

11 C.G. Jung, *Aspects of the Feminine*, first published 1982, Ark edition 1986, p.10.

12 Kapoor's restricted range of motifs might also suggest the vestigial influence of the Minimalists' practice of employing a limited vocabulary of given shapes.

13 See Neumann for a full discussion of this subject.

14 See Neumann pp.45–6.

15 This latter image is reminiscent of the image of two urns performing the alchemical act of *coniunctio* above and within a mountain in an engraving of 1617 of Maria Prophetissa reproduced in Jung's, *Psychology and Alchemy*, fig. 78.

16 See 'Study for the Kneeling Leda' c.1505–7, repr. *Leonardo da Vinci*, exh. cat., South Bank Centre, 1989, p.148 (col.).

17 Neumann, p.49.

18 See Neumann, p.4.

19 T.S. Eliot, 'East Coker', III, v.121, *Four Quartets*.

20 There are obviously precedents for Kapoor's use of the circular void to express the *horror vacui*, one of the most famous being plate 17 of William Blake's *Urizen* which depicts 'a round globe of blood trembling upon the Void'. Blake also uses the globe to denote godliness as in 'The Sun at His Eastern Gate' (Martin Butlin, *William Blake*, exh. cat., Tate Gallery, 1978, no.241 repr. in col.).

21 Hugh Blair, *Lectures on Rhetoric and Belles Lettres*, third edition, 1787, p.58, quoted in Andrew Wilton, *Turner and the Sublime*, exh. cat., British Museum, 1980, p.10.

22 Edmund Burke, *A Philosophical Enquiry into the Origin of our Ideas of the Sublime and Beautiful*, 1759, The Scholar Press, 1970, pp.58–9.

23 Burke, p.85

24 Thomas McEvilley, 'The Darkness Inside a Stone', *Anish Kapoor*, British Council, p.20.

25 T.S. Eliot, 'Burnt Norton', II, vv.62–78, *Four Quartets*.

26 Kapoor's drawings on paper are not studies for sculpture but independent works of art. When making studies for sculpture he tends to draw on the wall of his studio.

27 In this regard Kapoor's works may be equated with the shamanistic concerns of Joseph Beuys. Both artists deal with cosmic themes relating to the mysteries of life and procreation.

28 According to Jung if a separated state is assumed at the start 'then a union of opposites [earth and water for example] is performed under the likeness of a union of male and female . . . followed by the death of the product of the union . . . and a corresponding *nigredo*'. Jung, *Psychology and Alchemy*, pp.230–1.

29 Among other important influences on Kapoor's perception of colour is the use of red in Indian rituals.

30 Jung, *Psychology and Alchemy*, p.232.

31 Wassily Kandinsky, *Concerning the Spiritual in Art*, first published 1910, Dover edition, 1977, p.39.

32 National Gallery of Art, Washington, repr. Michael Compton (ed.), *Mark Rothko 1903–1970*, exh. cat., Tate Gallery, 1987, p.112 (col.).

33 Letter from Rothko and Gottlieb to Edward Alden Jewell published in the *New York Times*, 13 June 1943, quoted in Bonnie Clearwater, 'Selected Statements by Mark Rothko' in Michael Compton (ed.), *Mark Rothko 1903–1970*, p.69.

34 Quoted in Bonnie Clearwater, p.70.

35 Private collection, repr. Harold Rosenberg, *Barnett Newman*, New York 1978, p.40 (col.).

36 Parallels between alchemy, the sexual act and reproduction are commonplace in alchemical literature.

37 'East Coker', V, vv.178–89, *Four Quartets*.

Plates

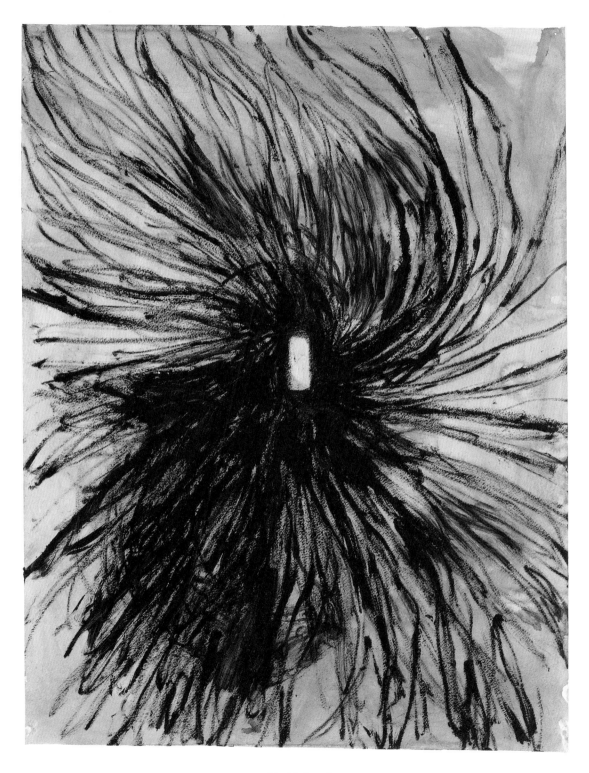

1 *Untitled* 1984

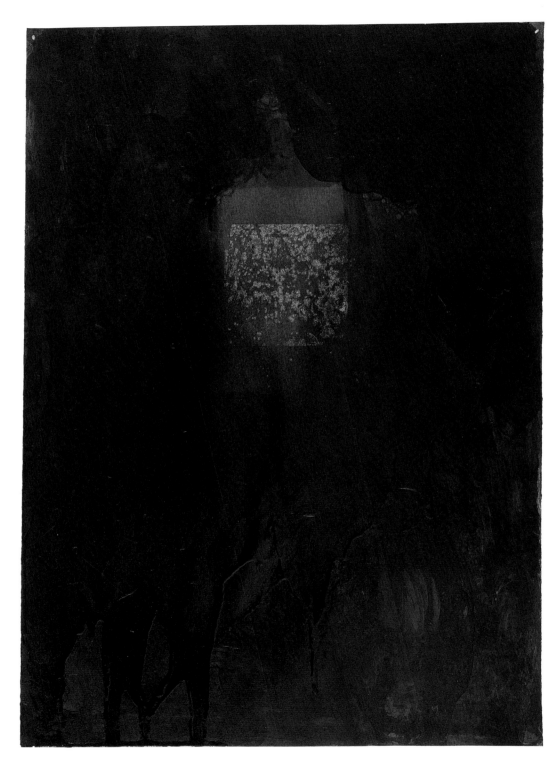

2 *Untitled* 1984

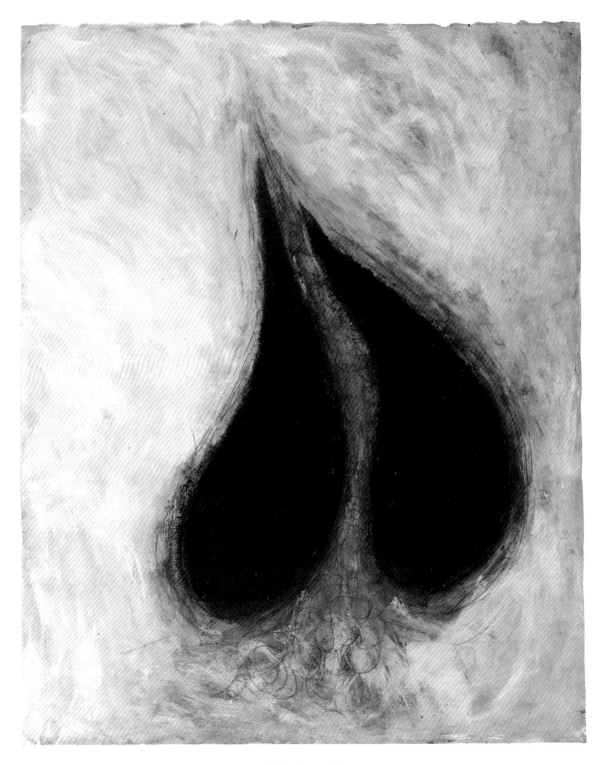

8 *Untitled* 1986

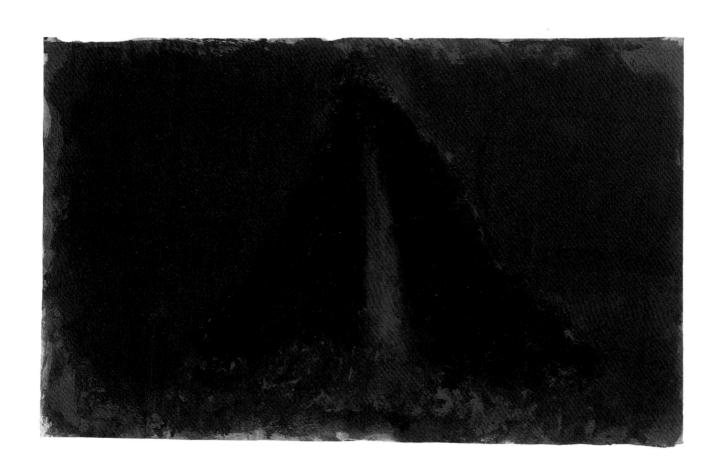

12 *Untitled* 1986

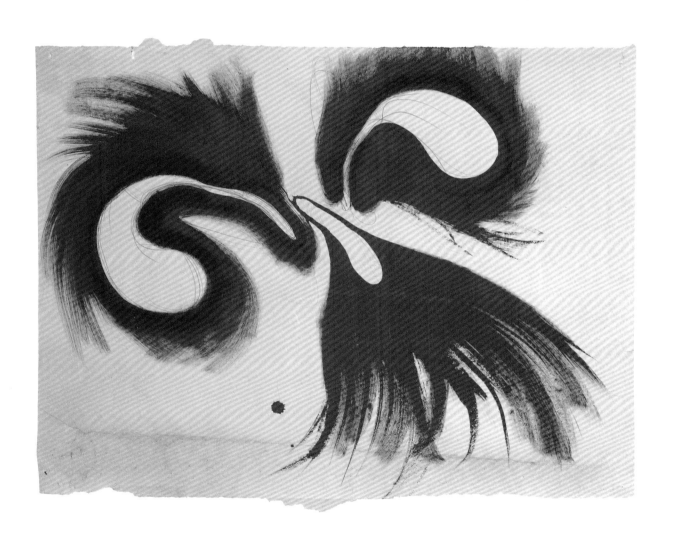

14 *Untitled* 1986

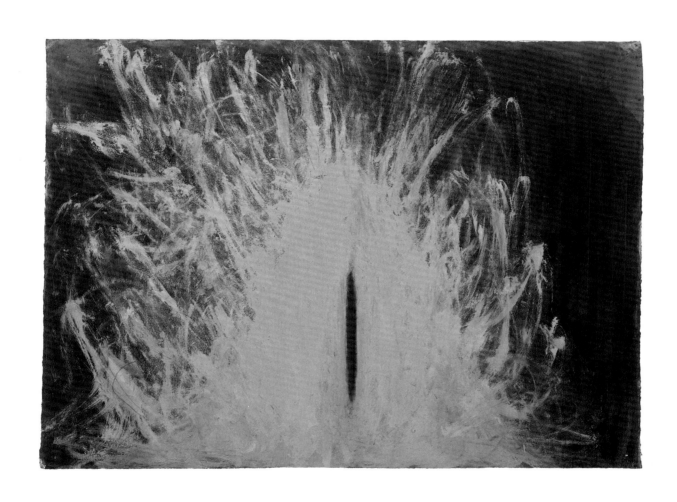

17 *Untitled* 1987

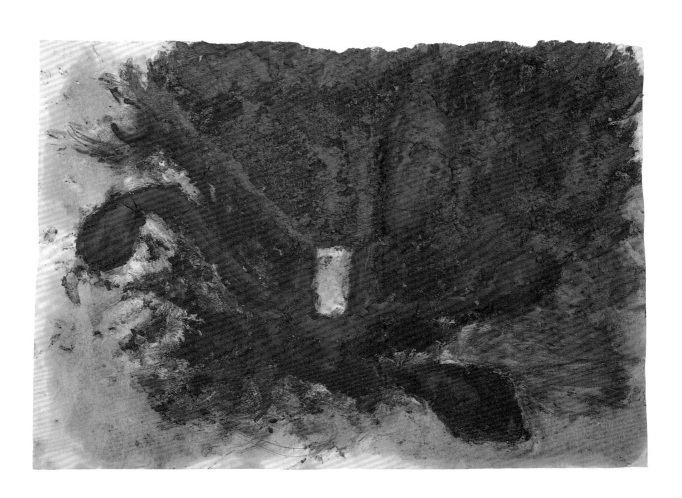

24 *Untitled* 1987

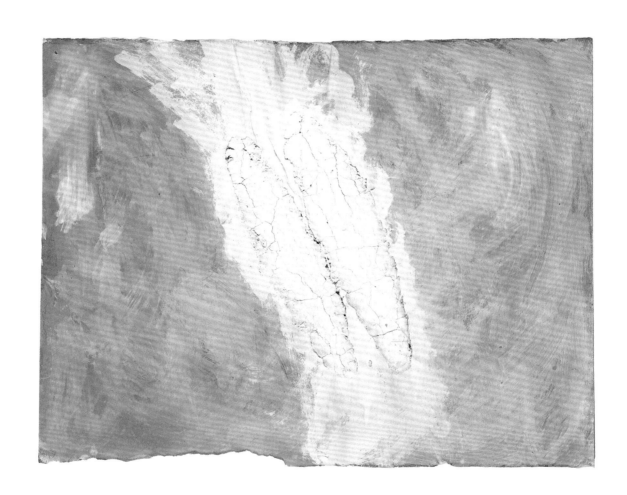

27 *Untitled* 1987

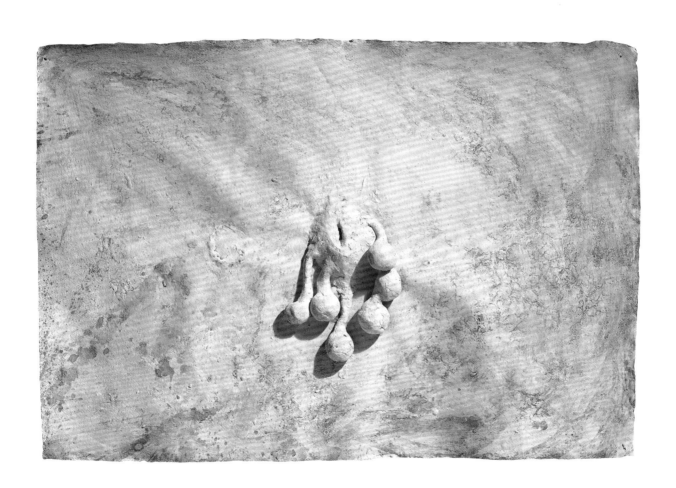

28 *Untitled* 1987–8

37

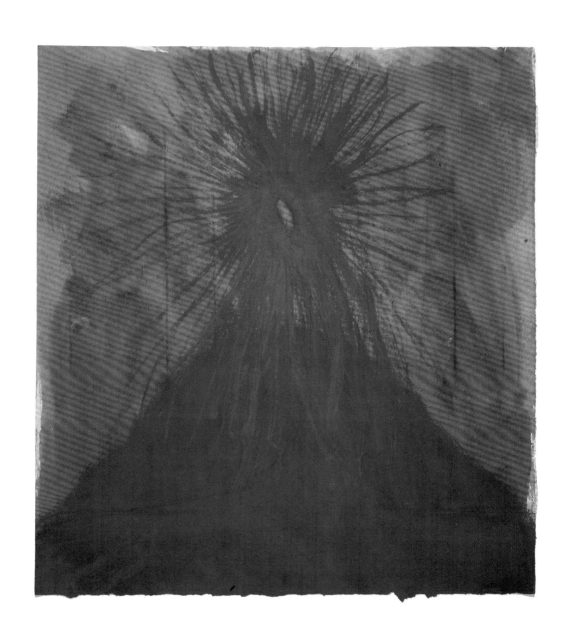

29 *Untitled* 1988

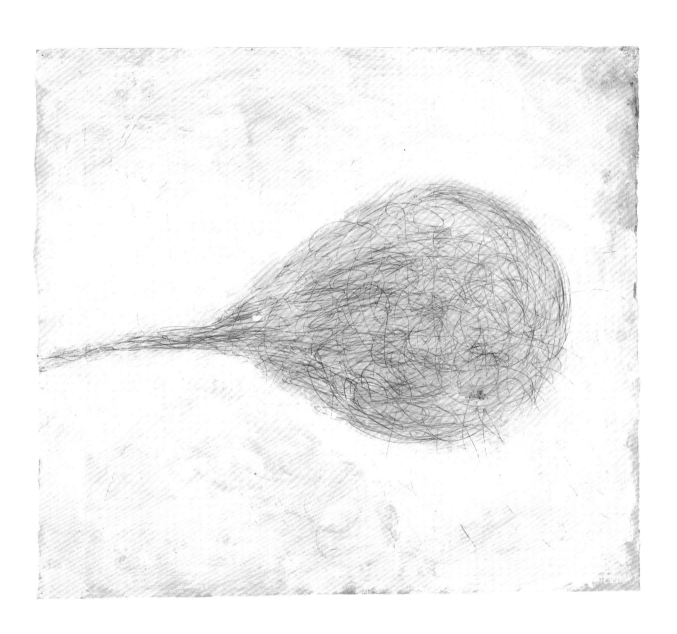

34 *Untitled* 1989

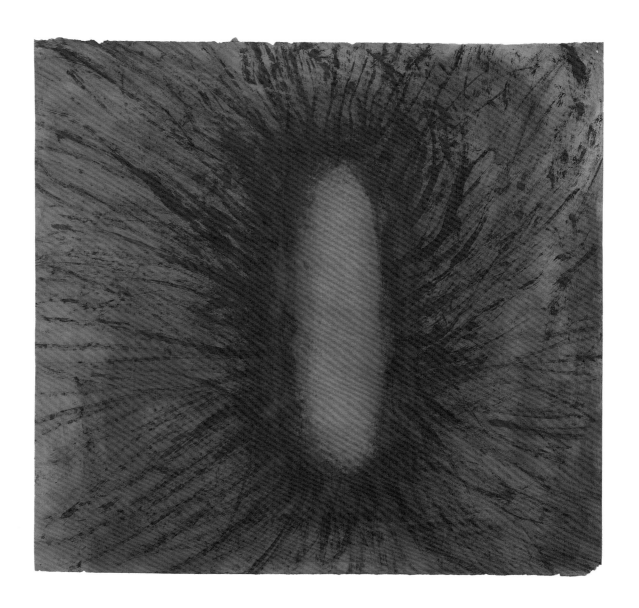

35 *Untitled* 1989

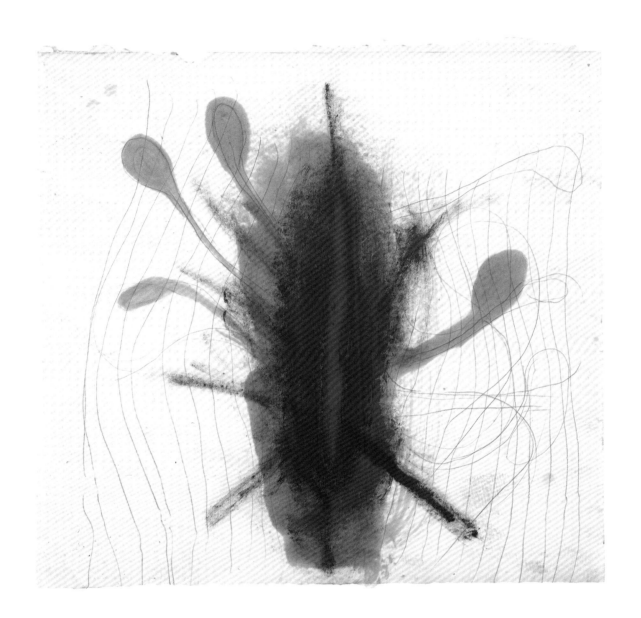

37 *Untitled* 1989

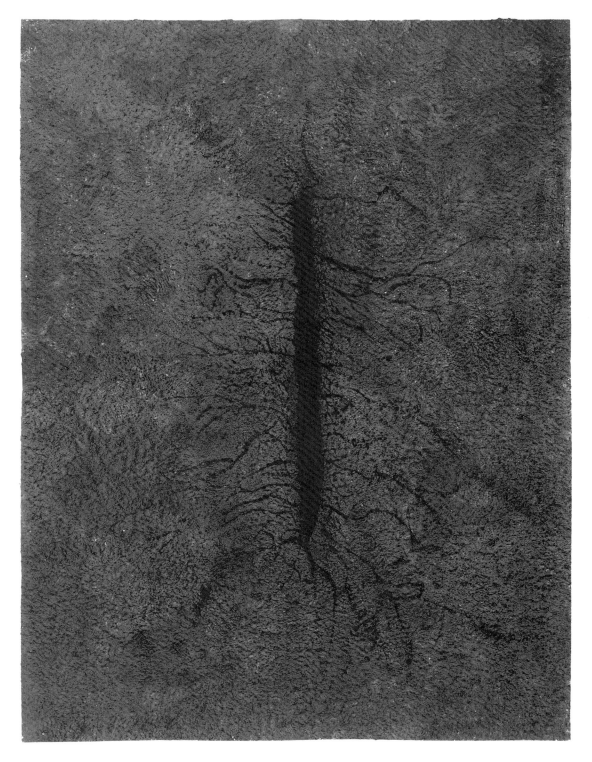

40 *Untitled* 1989

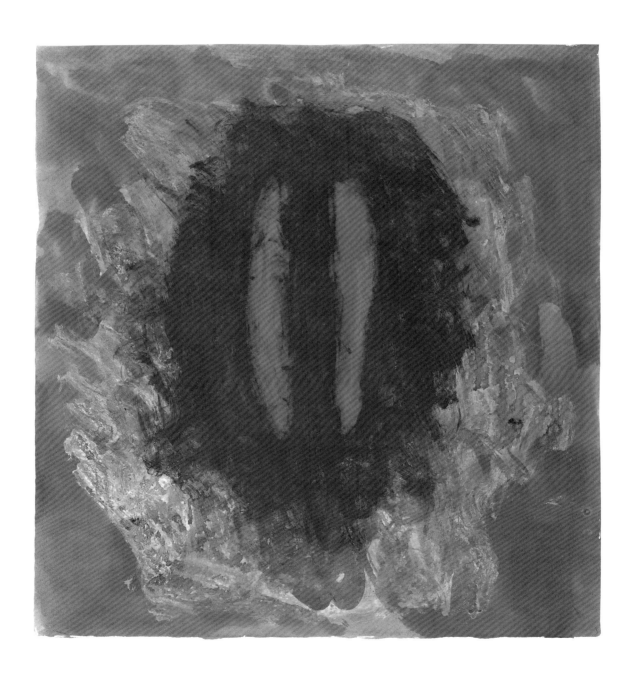

41 *Untitled* 1989

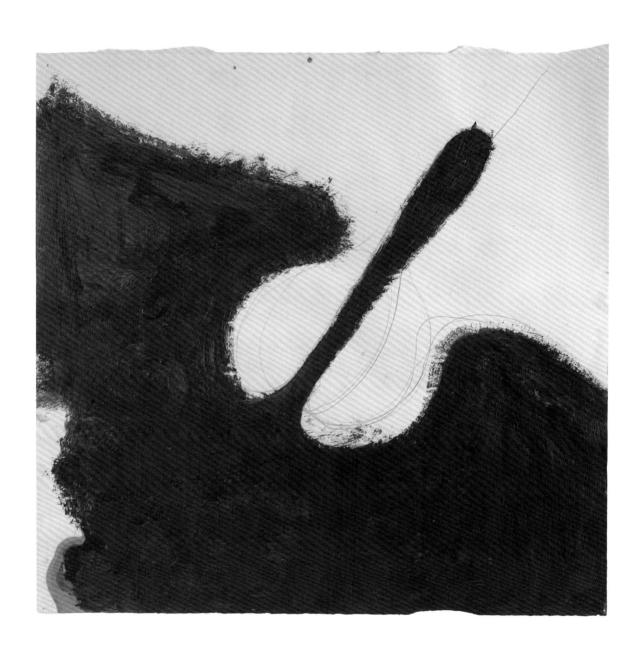

42 *Untitled* 1989

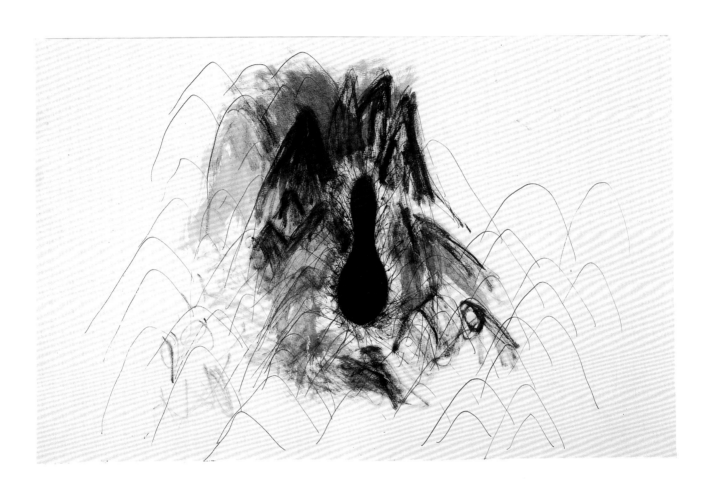

48 *Untitled* 1989

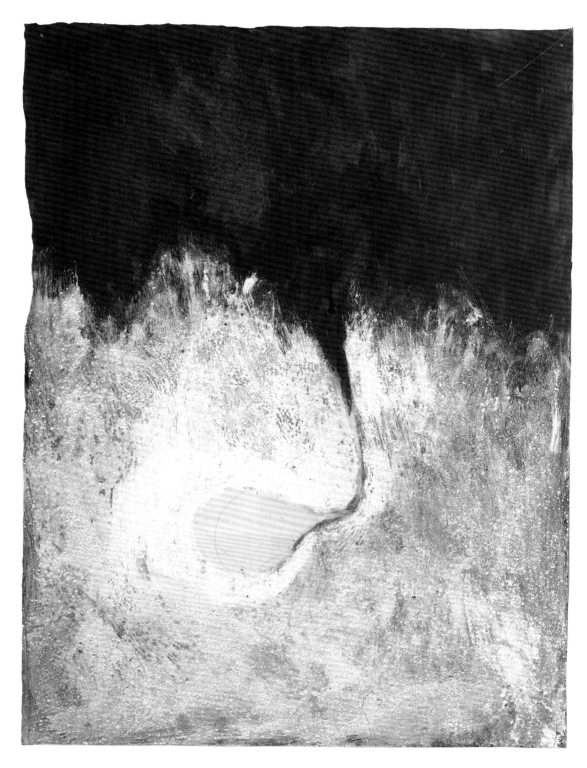

49 *Untitled* 1989

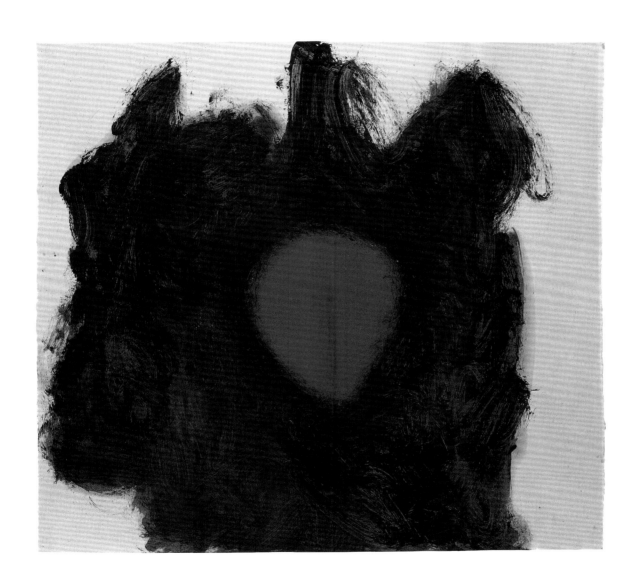

51 *Untitled* 1989

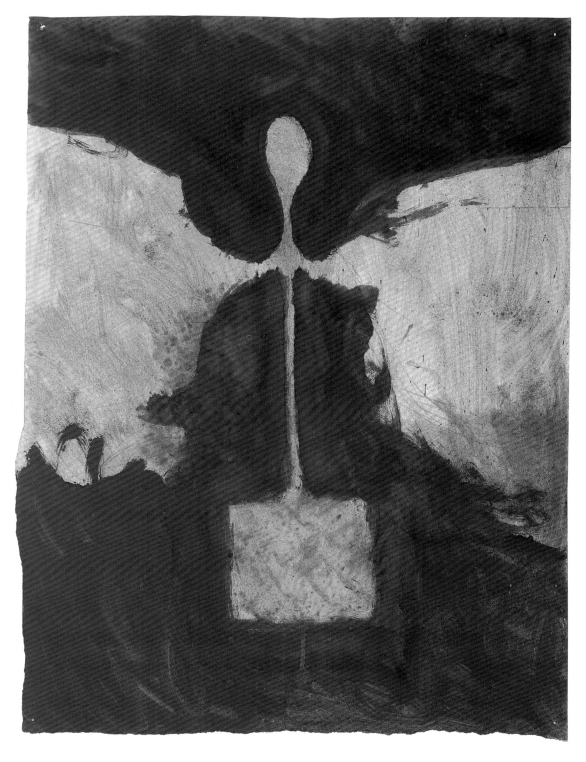

55 *Untitled* 1989

48

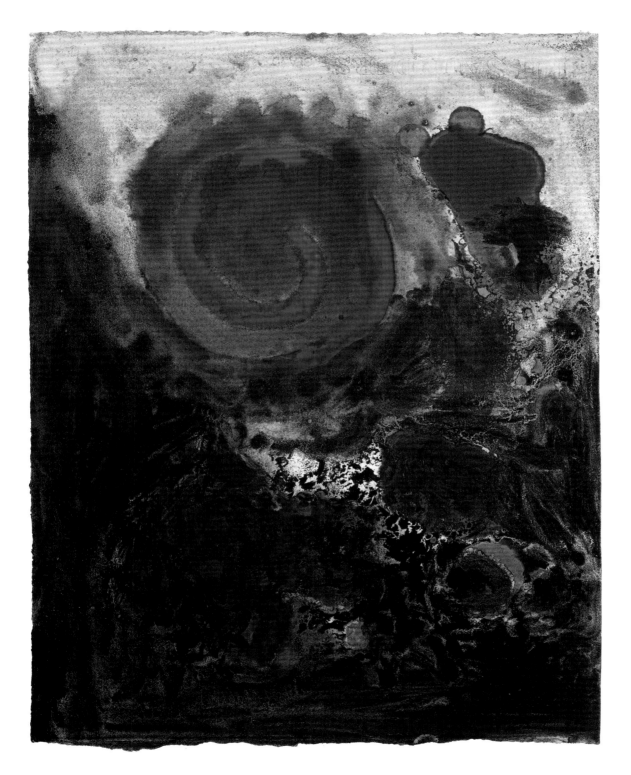

56 *Untitled* 1989

57 *Untitled* 1989

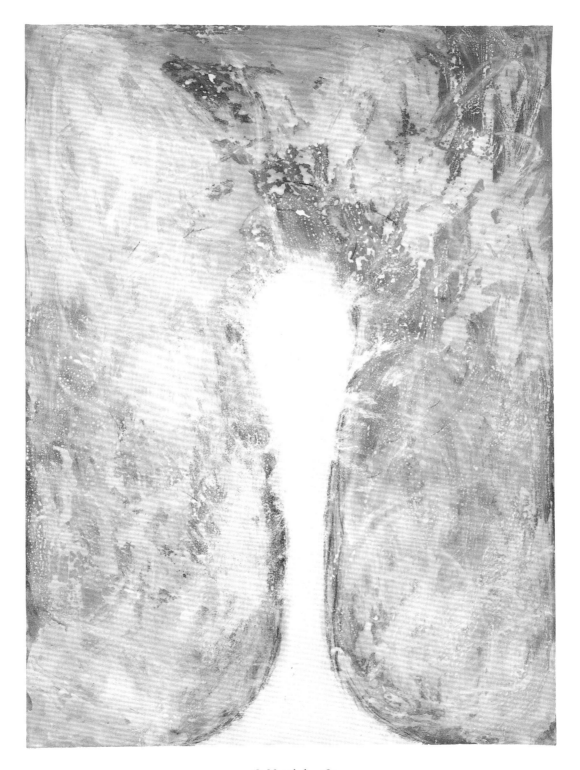

58 *Untitled* 1989

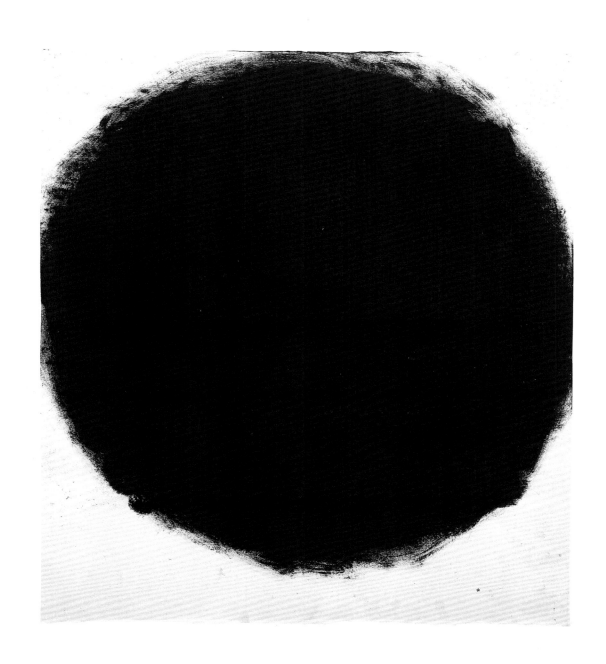

59 *Untitled* 1989

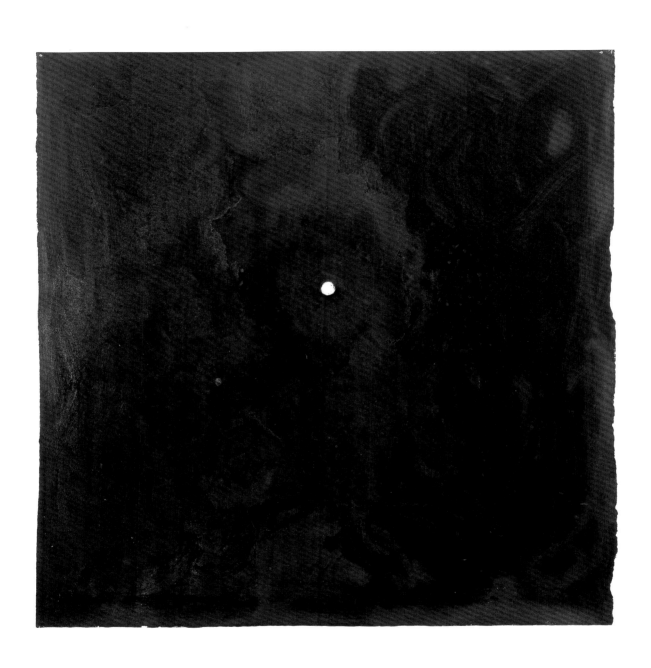

60 *Untitled* 1989

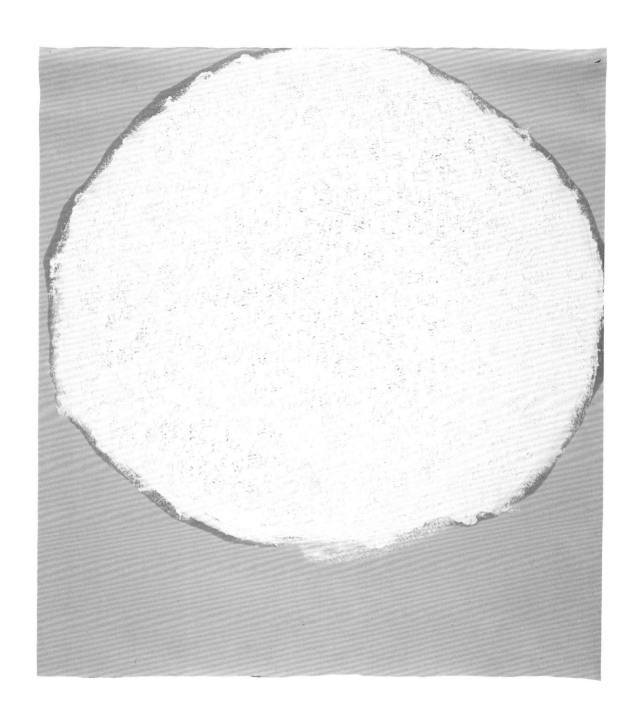

63 *Untitled* 1989

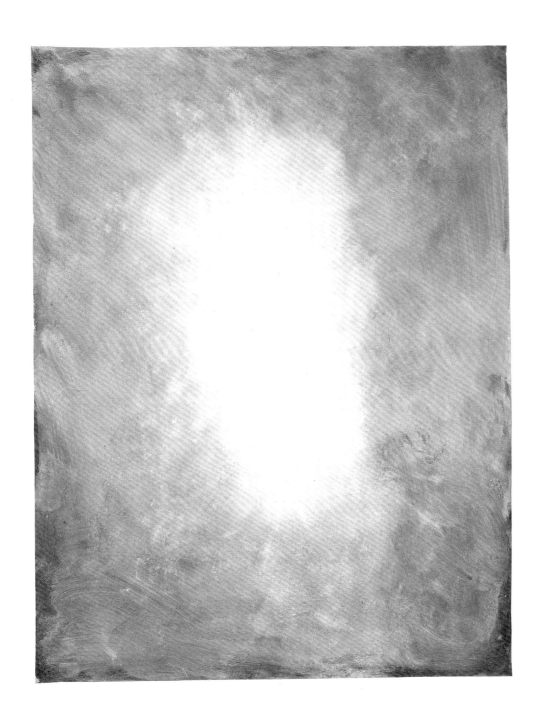

64 *Untitled* 1989

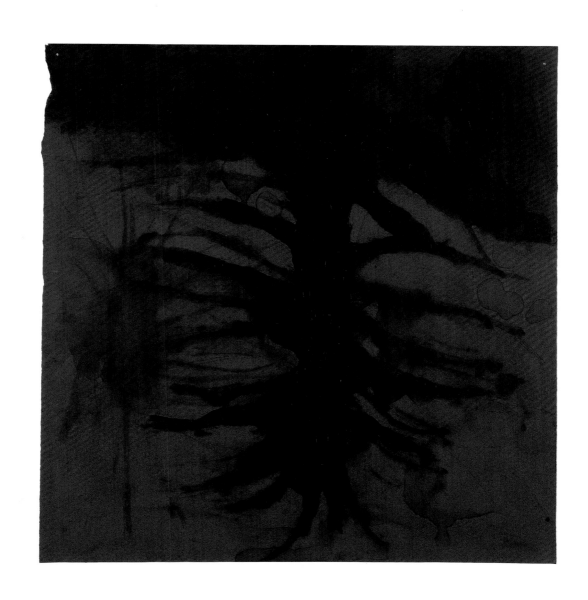

67 *Untitled* 1989

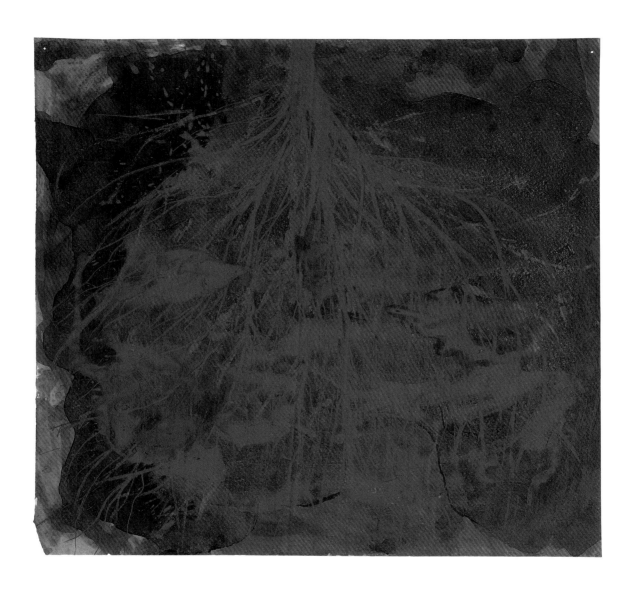

68 *Untitled* 1989

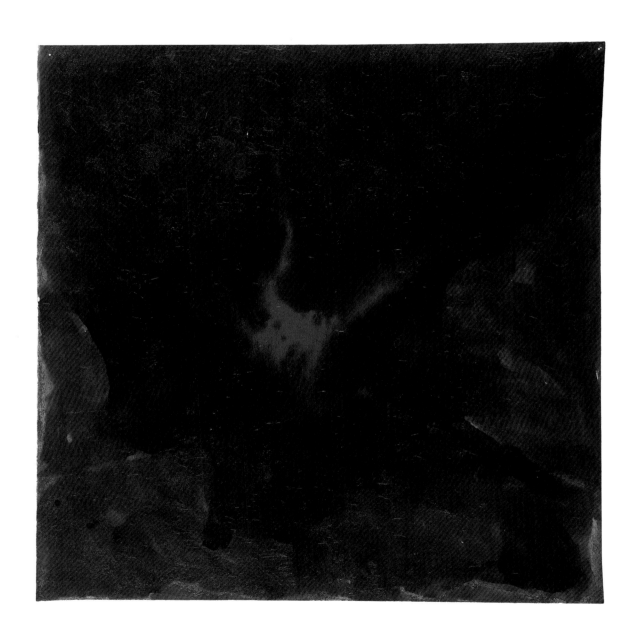

72 *Untitled* 1989

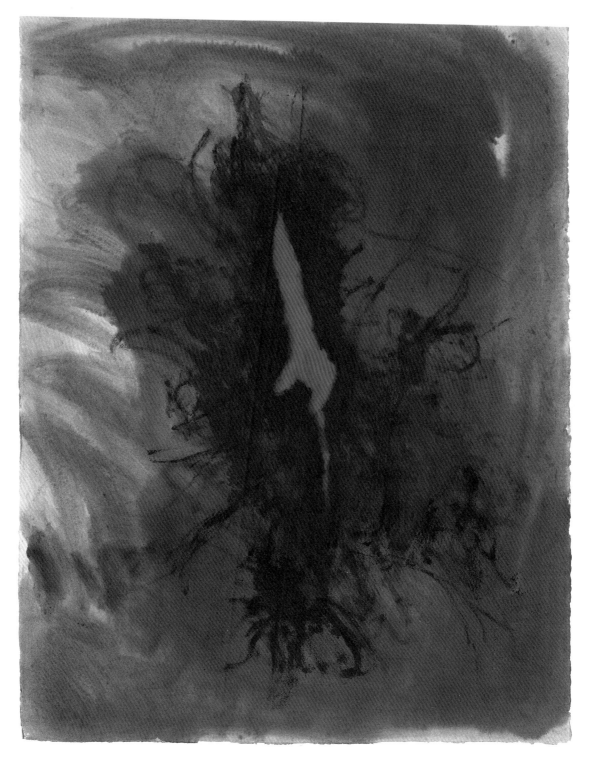

73 *Untitled* 1990

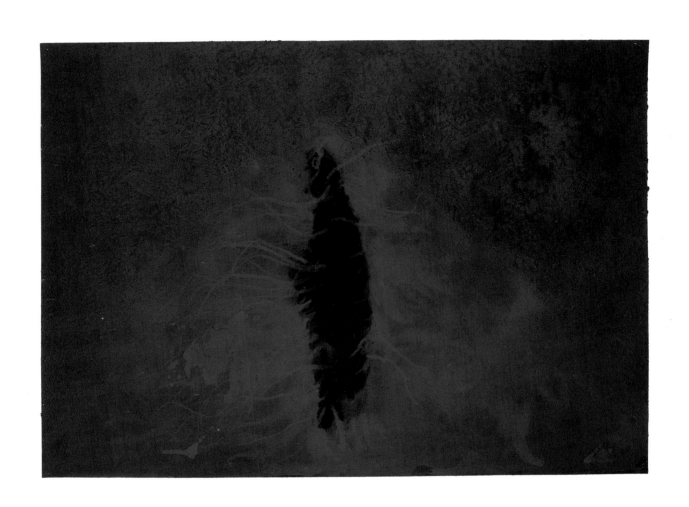

74 *Untitled* 1990

Catalogue

Measurements are given in centimetres; height precedes width followed, where relevant by depth.
Works illustrated in colour are marked *

1
Untitled 1984 *
Acrylic medium and pigment on
paper 74.7 × 55
Courtesy of the Lisson Gallery

2
Untitled 1984 *
Varnish and gold leaf on paper
50 × 35
Courtesy of the Lisson Gallery

3
Untitled 1985
Acrylic medium, earth, gouache
and pencil on paper 36.5 × 50.5
Collection of the artist

4
Untitled 1985
Gouache, emulsion and pencil on
paper 30 × 45.5
Collection of the artist

5
Untitled 1985
Earth, gouache and ink on paper
36 × 51
Collection of the artist

6
Untitled 1985
Ink and gouache on paper
31 × 45.5
Collection of the artist

7
Untitled 1986
Ink on paper 31 × 44
Tate Gallery

8
Untitled 1986 *
Gouache, ink, pencil, pigment
and emulsion on paper 74.5 × 56
Collection of the artist

9
Untitled 1986
Gouache and ink on paper
45.7 × 30.5
Courtesy of the Lisson Gallery

10
Untitled 1986
Ink and pencil on paper 30 × 46.8
Courtesy of the Lisson Gallery

11
Untitled 1986
Ink on paper 42 × 30
Courtesy of the Lisson Gallery

12
Untitled 1986 *
Earth, acrylic medium and
gouache on paper 29.7 × 45.5
Collection of the artist

13
Untitled 1986
Gouache and ink on paper
45 × 60
Collection Lady Latymer,
Majorca

14
Untitled 1986 *
Gouache and pencil on paper
45.5 × 56
Courtesy of the Lisson Gallery

15
Untitled 1987
Gouache on paper 39 × 30
Tate Gallery

16
Untitled 1987
Ink, gouache and pencil on paper
76 × 56
Courtesy of the Lisson Gallery

17
Untitled 1987 *
Tempera and pigment on paper
56 × 76.5
Courtesy of the Lisson Gallery

18
Untitled 1987
Acrylic medium, pencil and
pigment on paper 55 × 59.3
Courtesy of the Lisson Gallery

19
Untitled 1987
Gouache, emulsion and pencil on
paper 66.3 × 39.5
Courtesy of the Lisson Gallery

20
Untitled 1987
Earth, PVA and papier maché on
paper 44.5 × 57.6 × 5
Courtesy of the Lisson Gallery

21
Untitled 1987
Papier maché, PVA and emulsion
on paper 47 × 55.7 × 2.5
Collection of the artist

22
Untitled 1987
Papier maché and gouache on
paper 30.5 × 45.8 × 2.5
Courtesy of the Lisson Gallery

23
Untitled 1987
Earth, gouache and PVA on paper
30 × 46
Collection of the artist

24
Untitled 1987 *
Self hardening clay, PVA and
pencil on paper 40.5 × 56 × 1
Collection of the artist

25
Untitled 1987
Gouache and ink on paper
57 × 42
Courtesy of the Lisson Gallery

26
Untitled 1987
Gouache and pencil on paper
40.5 × 56
Courtesy of the Lisson Gallery

27
Untitled 1987 *
Papier maché, emulsion and ink
on paper 44 × 55
Collection of the artist

28
Untitled 1987–8 *
Gouache on paper 54 × 76 × 5
Tate Gallery

29
Untitled 1988 *
Gouache on paper 42 × 35
Tate Gallery

30
Untitled 1988
Gouache on paper 56 × 56
Tate Gallery

31
Untitled 1988
Ink and emulsion on paper
46 × 33
Collection of the artist

32
Untitled 1988
Oil and emulsion on paper
75 × 55
Courtesy of the Lisson Gallery

33
Untitled 1988
Emulsion and ink on paper
63.5 × 51
Collection of the artist

34
Untitled 1989 *
Oil and pencil on paper 50 × 53.3
Courtesy of the Lisson Gallery

35
Untitled 1989 *
Ink and oil stain on paper 54 × 55
Collection of the artist

36
Untitled 1989
Gouache and oil on paper
51.5 × 56
Courtesy of the Lisson Gallery

37
Untitled 1989 *
Ink, stain, gouache and pencil on
paper 55 × 55.3
Courtesy of the Lisson Gallery

38
Untitled 1989
Gouache and ink on paper
51 × 56
Courtesy of the Lisson Gallery

39
Untitled 1989
Varnish and pencil on paper
52.5 × 50
Courtesy of the Lisson Gallery

40
Untitled 1989 *
Earth and gouache on paper
76 × 56
Collection of the artist

41
Untitled 1989 *
Gouache and ink on paper
59.5 × 54.7
Courtesy of the Lisson Gallery

42
Untitled 1989 *
Acrylic, oil stain and pencil on
paper 57.5 × 56
Courtesy of the Lisson Gallery

43
Untitled 1989
Gouache on paper 62.5 × 56
Courtesy of the Lisson Gallery

44
Untitled 1989
Gouache, emulsion, ink and
pencil on paper 54.5 × 37.5
Courtesy of the Lisson Gallery

45
Untitled 1989
Gouache and varnish on paper
56.2 × 38
Courtesy of the Lisson Gallery

46
Untitled 1989
Gouache and pencil on paper
39.5 × 30.3
Courtesy of the Lisson Gallery

47
Untitled 1989
Gouache and ink on paper
37.5 × 54.8
Courtesy of the Lisson Gallery

48
Untitled 1989 *
Ink on paper 37.5 × 55
Courtesy of the Lisson Gallery

49
Untitled 1989 *
Acrylic, pigment, ink and pencil
on paper 56.7 × 41.5
Collection of the artist

50
Untitled 1989
Gouache, ink and pencil on paper
37 × 54.5
Collection Samuel Lallouz,
Montreal

51
Untitled 1989 *
Oil and gouache on paper 50 × 54
Collection of the artist

52
Untitled 1989
Varnish and gouache on paper
56 × 60
Courtesy of the Lisson Gallery

53
Untitled 1989
Gouache, pencil and ink on paper
50 × 32.5
Courtesy of the Lisson Gallery

54
Untitled 1989
Acrylic, gouache, pencil and oil
stain on paper 56.5 × 58.5
Courtesy of the Lisson Gallery

55
Untitled 1989 *
Ink on paper 56.7 × 43
Collection Romieri, Milan

56
Untitled 1989 *
Varnish, ink and gouache on
paper 50 × 38.5
Collection of the artist

57
Untitled 1989 *
Gouache, pigment and damar on
paper 70 × 49.8
Collection of the artist

58
Untitled 1989 *
Oil, gouache, ink and pencil on
paper 70 × 50
Courtesy of the Lisson Gallery

59
Untitled 1989 *
Pigment and damar on paper
56 × 50
Courtesy of the Lisson Gallery

60
Untitled 1989 *
Varnish and pigment on paper
56 × 55
Courtesy of the Lisson Gallery

61
Untitled 1989
Gouache and damar on paper
70 × 50
Courtesy of the Lisson Gallery

62
Untitled 1989
Oil and emulsion on paper
76 × 56
Courtesy of the Lisson Gallery

63
Untitled 1989 *
Mixed media on paper 58 × 50
Courtesy of the Lisson Gallery

64
Untitled 1989 *
Oil and gouache on paper
75 × 54.5
Collection of the artist

65
Untitled 1989
Emulsion, oil and ink on paper
75 × 54.5
Courtesy of the Lisson Gallery

66
Untitled 1989
Gouache and unfixed pigment on
paper 62 × 54.7
Collection Edwin Cohen,
New York

67
Untitled 1989 *
Varnish and pencil on paper
50 × 48
Courtesy of the Lisson Gallery

68
Untitled 1989 *
Gouache on paper 49.8 × 53
Collection Edwin Cohen,
New York

69
Untitled 1989
Varnish and pigment on paper
70.2 × 50
Collection Pascal de Sarthe,
California

70
Untitled 1989
Oil and emulsion on paper
74 × 50
Collection Judith Moulding
Adelson, Los Angeles

71
Untitled 1989
Gouache, pencil and oil on paper
58.5 × 50
Courtesy of the Lisson Gallery

72
Untitled 1989 *
Varnish on paper 56 × 55.2
Courtesy of the Lisson Gallery

73
Untitled 1990 *
Gouache and ink on paper
76.5 × 56.5
Collection of the artist

74
Untitled 1990 *
Earth, PVA and gouache on
paper 56 × 76
Collection of the artist

Biography

1954
Born Bombay, India

1973–7
Hornsey College of Art, London

1977–8
Chelsea School of Art, London

1979
Taught at Wolverhampton Polytechnic

1982
Artist-in-Residence, Walker Art Gallery, Liverpool

1990
Awarded 'Premio Duemila' at Venice Biennale